JUST ENOUGH DESIGN

JUST ENOUGH DESIGN

Reflections on the Japanese
Philosophy of *Hodo-hodo*

BY TAKU SATOH

*Edited and translated by
Linda Hoaglund*

CHRONICLE BOOKS
SAN FRANCISCO

*Special thanks to Miyuki Tateno
and Allison Markin Powell.*

Library of Congress Cataloging-in-Publication Data available.

ISBN 978-1-7972-0990-6

Printed in China.

Design by Kayla Ferriera.
Typeset in Ricardo and Arno Pro.

10 9 8 7 6 5 4 3 2 1

Chronicle books and gifts are available at special quantity discounts to corporations, professional associations, literacy programs, and other organizations. For details and discount information, please contact our premiums department at corporatesales@chroniclebooks.com or at 1-800-759-0190.

Chronicle Books LLC
680 Second Street
San Francisco, California 94107
www.chroniclebooks.com

CONTENTS

INTRODUCTION
by Linda Hoaglund

This book began in 2019, when Taku Satoh asked me to work with him on an English-language book introducing his design philosophy. I had first met Taku ten years earlier. He had designed a book of photographs of clothing once worn by those who perished in Hiroshima, by the esteemed artist Ishiuchi Miyako, also the subject of my third film, *Things Left Behind*. Taku has been an esteemed and sought-after designer in Japan for decades and has created countless projects defying categorization—from the reusable whisky bottle that launched his career in 1984 to his worldwide advertising graphics for Issey Miyake's iconic Pleats Please clothing brand and the beloved children's TV series about the Japanese language that he art directs. Issey Miyake was so impressed by Taku's ingenious yet self-effacing solutions that he asked Taku to join him as a founding member of 21_21 DESIGN SIGHT, Japan's preeminent design exhibition space in Tokyo.

You may recognize Taku's bashful Pleats Please Penguin, but probably not Taku's name. This is because the key to his design philosophy is humility; he intentionally sets aside

his ego and his preconceptions in order to identify the essence of every project and render it visible. His primary goal as a designer is to facilitate communication. "After decades of working in the field, I am convinced that the definition of design is the skill to bring people and things together. Good design is devising smart connections," he says. "Connecting people and things means coming up with a unique approach each time. Maintaining the flexibility to respond to every project with a fresh strategy requires a supple thought process, rather than a single signature style. The essence of design can never be about expressing your personality."

Taku came of age in the 1960s, at the dawn of Japan's "economic miracle," when the legacies of Japan's preindustrial past remained entwined with the objects and customs of everyday life. Craftspeople took great pride in painstakingly fashioning toys, utensils, and tools by hand, using organic materials and selling them at prices most people could afford. Although Japan had largely recovered from the extreme poverty of the 1940s and '50s during and after World War II, clothes and other goods were still treated with respect, handled with care, and when damaged, mended or repaired to extend their longevity, not thrown away. These customs and essential values of Taku's childhood form the foundations of his philosophy today and galvanize his critiques of the ubiquitous conveniences spawned by Japan's booming economy in the 1980s. Early in his career, as Japan's economy was reaching its peak, long before sustainability had become the watchword it is today, Taku created a whisky bottle whose design inspires people to repurpose it years after they've consumed the last drop of whisky.

The roots of Taku's approach to design can be directly traced from his childhood all the way back to Japan's Edo era.

**PLEATS
PLEASE**

ISSEY MIYAKE

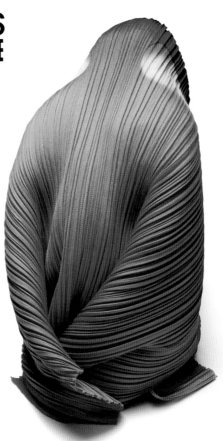

For two and a half centuries (1603 to 1868), Japan isolated itself from the world and prospered in peace, inadvertently postponing industrialization until the late nineteenth century. Although Japan's capital was then an urbane metropolis with a population larger than contemporaneous London, everything was still made by hand. Meticulously handcrafted woodblock prints depicting Mount Fuji, Kabuki stars, and the now iconic Great Wave could then be purchased for the price of a bowl of noodles.

Artisans became apprentices at twelve, trained for a decade, and dedicated the rest of their lives to perfecting their craft. These 職人 *shokunin* handmade everything from textiles to tatami mats, from brooms to umbrellas, from woodblock prints to folding screens. Although their creations were elegant and refined, they didn't consider them works of art or sign them. Nor did the shokunin call themselves artists. They valued their creations over their egos. Indeed, at that time, there wasn't even a word for "art" or "artist" in the Japanese language, as the beautiful objects artisans created were so integrated into the practical functions of daily life. The large-scale folding screens, *byōbu*, that Taku references in the opening chapter are stunningly beautiful works of art that have been collected by major museums around the world, but they also once served as room dividers.

Nor was there a word for "garbage" or "trash" during the Edo period, because literally nothing was ever thrown away. Instead, things were constantly reused and repurposed. The secondhand kimono markets did a brisk business. Bolts of cloth, handwoven in dimensions yielding just enough fabric to stitch into a single kimono, were resewn into futon covers when the garments eventually frayed, and were finally converted into cleaning rags, which were tossed in with the

human refuse to fertilize farmers' fields when they became shredded beyond use.

Today in Japan, some are working to reclaim both the physical objects and the cultural values of the Edo era. For the past ten years, Taku has been the creative director for several businesses in a World Heritage Site that exemplifies this. Iwami Ginzan was resurrected from the ruins of a silver mining city that prospered in the Edo era but was abandoned when the mines closed. The community's goal is to rediscover treasures from the past and creatively adapt them for their lives today, always in harmony with nature. The artisanal clothing brand Gungendō, for example, is based in a traditional farmhouse and purposely integrates plant-based dyes and traditional methods to make fashionable clothes for contemporary life. Each year, more visitors are drawn to this remote town, nestled in the mountains,

to see the fruits of the community's collective efforts and stay in inns creatively refurbished from traditional Japanese homes. Other provincial villages across Japan are taking similar approaches, reevaluating their habitats, and restoring long-neglected artisanal methods and ways of life. Taku collaborates with them because he believes their approach may yet rescue Japan from its single-minded focus on financial prosperity.

When Taku and I met to discuss this book, we had no inkling that within a year's time, COVID-19 would abruptly stop the music, bring the world as we knew it to a screeching halt, and render our basic assumptions about life instantly obsolete. As we reevaluate our individual and collective priorities in the wake of a global pandemic, Taku's approach to design, rooted in Japan's centuries-long sustainable, artisanal methods, is suddenly, urgently relevant. Perhaps as we reconsider our future on this planet, it's also time to reevaluate what it means to live with just enough.

HODO-HODO NO DEZAIN

Just Enough Design

ほどほど *Hodo-hodo*, meaning "just enough," is a marvelous phrase rooted in ancient Japan. It dates back to at least the eleventh century when Lady Murasaki used it to mean someone of appropriate or suitable social stature in her pathbreaking novel, *The Tale of Genji.* Today it can mean everything from "so-so" to "leave well enough alone." *Hodo-hodo* is one of thousands of onomatopoeic singsong phrases in Japanese that intuitively convey a range of nuances depending on the context. The more projects I complete, the more I appreciate the depths of meaning in this phrase. In Japanese, *hodo-hodo* can mean letting go of something before it is completed. Applied to design, *hodo-hodo no dezain* could imply "just enough design." Which probably sounds like not very good design, but rephrasing it as "designing the hell out of a level that's just enough" or "perfecting the design of just enough" undoubtedly transforms your impression. In other words, the shade of meaning I want to convey with *hodo-hodo* is deliberately holding back, fully aware of the ideal of completion.

Holding back before completion gives us precisely the room that we need to respond to any object according to our unique sensibilities. You could say that this space is what allows us to customize our relationships with objects. Each individual has a particular set of values and behaviors. Thus, when presented with an object that has no space left, many of us feel walled in, with no room to breathe. When an object feels like it's taunting us, saying "Use me this way!" or when it is so stunning that no one can imagine how to put it to use, this is because it has no space. Brands and designers often race single-mindedly to perfect something as though it's a work of art. But design has no inherent value. Its value is only born of the relationship that individuals develop with an object. Given that we each have our own priorities, shouldn't we hold back design at just enough, leaving room to accommodate a range of interactions? This is how space is created.

There is a valuable lesson about the role of design buried in the ambiguous phrase *hodo-hodo*. And the basic implements Japanese people have been using for centuries offer glimpses of hodo-hodo at work.

By reconsidering everyday tools through the lens of our relationship with them, we can see a distinctly Japanese approach to design. For instance, a utensil premised on the abilities of those who use it. The best example is Japanese 箸 *hashi*, known in the West as chopsticks, which we use to eat. By expertly deploying two sticks identically tapered at one end, you can pick up anything from tiny grains of rice and beans to a large potato. This remarkably simple tool can be used to separate pieces of meat, pierce and divide soft foods, stir up miso soup, carry slippery wakame seaweed into our mouths, wrap nori around rice, and so many other things. Because we have been using them since childhood, we deftly and instinctively manage these two sticks every day.

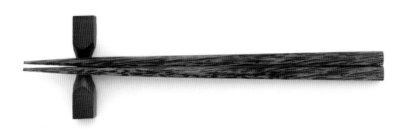

In hashi, you can see a "design relationship" entirely different from the Western knife and fork. The modern knife and fork each have a handle, enlarged for easy grasping, and the contour of the handle is often a design feature. Compare this to hashi, which are designed without handles or indeed any indication of how to hold them. The design of hashi is not design that instructs us, "Use me this way." Instead, hashi are essentially two sticks that somewhat indifferently suggest, "Use me however you want." So I can imagine that hashi may flummox people from other countries who first encounter them. But once you figure them out, their high functionality as eating utensils makes them irreplaceable.

The simplicity of two sticks motivates basic human potential along with our capacity for gestural elegance. In Japan, people never sought to make hashi more convenient. Thus, hashi did not evolve like the knife and fork did in the West, but essentially remained two sticks. They are distinguished from their Chinese and Korean counterparts by being made out of wood or bamboo instead of metal, and by the subtle adaptation of tapered tips to maximize their response to delicate human manipulation. Hashi also convey

Japanese traditions when they are painstakingly lacquered or crafted from select timbers. In this way, everyday life reveals a Japanese approach to design, holding back at just enough in order to ace it.

Utensils have evolved based on the human relationship to food, so they must be evaluated within the context of every nation's or region's culinary culture. Nevertheless, with international foods now so widely available through global distribution, hashi remain distinctly Japanese, and as Japanese cuisine enjoys a global boom, it's worth noting the growing number of people outside Japan now fluent in hashi. Instead of focusing on specific design projects flamboyantly executed by famous designers, let us look to the humble hashi, designed anonymously, amply suffused with Japanese design that we can proudly show off to the world.

And let us not forget the 風呂敷 *furoshiki*, the square piece of fabric used to wrap and carry anything. Furoshiki can be wrapped in dozens of different ways to accommodate anything that needs bundling and can be folded up and tucked away when not in use. It is held back at the level of a single piece of fabric that the user is free to improvise with. Intentionally designed to have no handles or seams shaping it into a bag, it is always used in its original form. In our headlong rush to prioritize convenience, this tool might have already become obsolete. Nevertheless, remarkably, the furoshiki, bursting with the potential to stimulate human intelligence and adaptability, has managed to survive into a time when anything and everything can be delivered to our doors. It is the quintessence of just enough design that doesn't overdo it. I hardly need to mention that because it is a simple square of fabric, the furoshiki's graphic design potential is wide open. In our age of convenience, we constantly generate new forms for every possible situation,

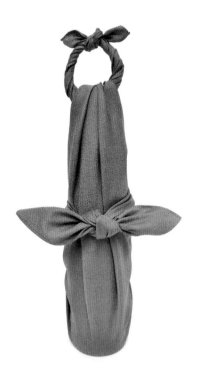

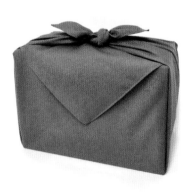

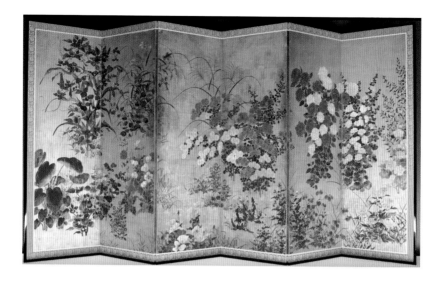

but because the design of this single piece of (in some ways inconvenient) cloth is so restrained, it serves as a nearly limitless canvas for self-expression.

Looking back to a slightly earlier way of Japanese life, we recognize that 屏風 *byōbu* reveal the same just enough design as hashi and furoshiki. These large-scale painted folding screens were opened up and positioned to partition rooms when needed, then folded up and stored away when not. I believe there are many other Japanese tools used in daily life in the past that deserve reviving today.

To think about design is to consider the meaning of prosperity. The definition of design is expanding. Design is present everywhere. Not just in tangible objects such as products but also in the systems and mechanisms invisible to the eye. National policy is the design of governance, based on an accurate assessment of the country's place in the world. Design is inherent in politics, economics, health care, social welfare, and education. Everyone can perceive that letters are

designed, but the way I understand design, even words are the result of human design. From this perspective, civilization has been designed by human history. Today, as we confront a mountain of crises, from global warming to energy and food shortages and infectious diseases, we are in a critical time to reconsider what civilization has actually been about. From this vantage, let us question whether human beings have undertaken the right design direction. This requires us to reconsider the essence of prosperity.

Looking back at the second half of the twentieth century, it appears that we spent that era competing to perfect the tools of everyday life into objects of art. I wonder whether this is a goal worth pursuing in the twenty-first century. A quick survey of modern life reveals a multitude of remarkable, enduring tools akin to hashi, furoshiki, and byōbu, all inspired and sustained by the everyday rituals of Japan, all the epitome of hodo-hodo. Today, as our misguided and excessive pursuit of convenience increasingly eliminates the need to engage our bodies and even our hearts, it is time to reexamine what it means to perfect just enough. This inquiry is integrally related to the crises we face in resources and energy as well as in our cultural values.

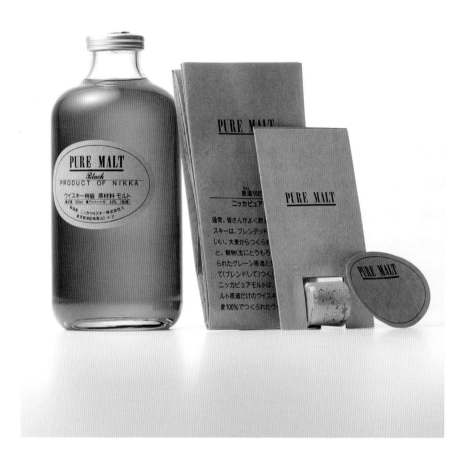

DESIGNING THE USER EXPERIENCE
Nikka Whisky Pure Malt (1984)

My first project as a freelance designer was launching Nikka Pure Malt, a new whisky developed by the Nikka Whisky Distilling Company, the major Japanese distillery founded in 1934. I started by developing a full presentation for naming, bottle volume, packaging, pricing, marketing, and publicity on spec, then continued to work on the project until its product release in 1984. The 500-milliliter bottle (about one pint) was ideal for customers to comfortably consume at home, as extended families shrank into smaller, nuclear families. The pint-size bottles were also tailored for women to feel comfortable purchasing. The price was 2,500 yen, equivalent to an LP vinyl record at the time. The bottle was stripped of personality to blend into any environment. The resulting vessel could be repurposed after the whisky was gone. Because the bottle came with a cork, there was no need for a screw thread at the neck. We used a water-soluble glue to affix the label for easy removal.

We deliberately excluded this information from the packaging. Because the design of the bottle did not overtly

assert itself, it subtly elicited the consumer's desire to value it as an object and reuse it instead of getting rid of it after drinking the whisky. The advertising campaign was built on the efficient use of print media, eschewing massively expensive TV commercials. This allowed us to devote more of the budget to the product itself, making the elegant packaging possible. When people encounter a new product, they are usually attracted by its visual appeal. If they are interested, they take it in hand, pay for it, carry what they now own home, open the box, remove the cap, pour a drink, savor the music of ice on glass, then cork the bottle. If they realize that they can repurpose the bottle after the whisky is

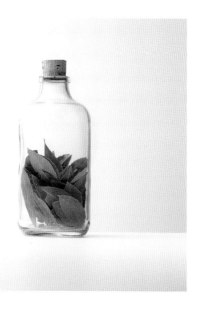

finished, they hold on to it. As we repeated these simulations, it occurred to me that what we had actually designed was the user's experience. When we buy whisky, or any alcoholic beverage, we are also acquiring the pleasure of the moments we will spend with it. Working on this project taught me to think through what it means to design.

DESIGN IS EVERYWHERE

There is a general perception that only things that look obviously designed—for instance, things that are cool or fashionable—have actually been designed and that everything else has not. When design is defined this way, you cannot blame someone for assuming it is special, not an essential part of daily life. Somehow, we have been conditioned to think that design is out of the ordinary.

But in fact, design is hiding in plain sight, everywhere in our daily lives. We are mostly oblivious to it, recognizing it in only a fraction of deliberate design. Someone somewhere designed each and every letter of the alphabet you're reading in this essay, along with the blank spaces between the lines. The asphalt paving we rarely notice when walking down a road has been designed, along with the guardrails and traffic lights. The roads themselves have been designed. As human beings began walking around what were once vast open lands marked only by animal trails, roads began to form, and eventually humans began to deliberately plan roads as we do today. In other words, roads are designs

for human mobility. In this way, a multitude of all kinds of designs remain out of our sight. Anyone who claims, "We don't need design" or "There's something suspicious about design," misunderstands design. Any form of technology or information must be designed in some way in order to be communicated. This is an inescapable fact of human life that overrides individual beliefs or taste.

Of course, there are also a limited number of things, like lipstick cases and playgrounds for children, that need to be specially designed, but you will find most design embedded in the things we unconsciously interact with every day. Just as design can be deliberately obscured to remain invisible, design can also reveal the essence of things that are hard to comprehend, making them obvious to anyone. Because economic success has become the only measure of prosperity in contemporary society, we now perceive design as just a tool for making goods and services more conspicuous in order to sell them. Perhaps this is why many people are skeptical of design.

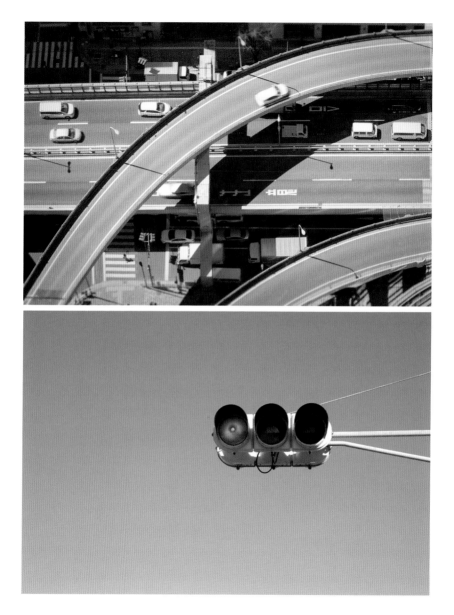

DESIGN AND RAMEN

The first serious pursuit of simple design was undertaken by Bauhaus. This German art school, established in the wake of World War I and shut down by the Nazi regime, was the driving force behind the modern design movement that spread across the globe. When modern design arrived in Japan in due course, it proved useful in many people's daily lives, but it was also exploited as an economic tool in tandem with Japan's postwar "economic miracle," precipitating a fundamental misperception. Modern design is simple because its creators recognized a rational aesthetic of efficiency and functionality in modern industry and developed an accordingly minimal design vocabulary. Nevertheless, as mass-produced products proliferated, stimulating material consumption, we convinced ourselves that simple, pared-down design was the only legitimate approach for the future, without ever grasping the essence of modern design or all the design that preceded it. This presumption persists to this day in phrases such as *designer home appliances*, revealing how the concept of "design" remains entirely misunderstood. This is the

unfortunate conclusion of exploiting design as a mere tool to sell things, without examining its fundamental nature.

Let us consider the ラーメン ramen Japanese love so much. Think back on a tasty ramen shop. Was it as immaculate as a hair salon? Did you eat your ramen in a spot resembling a brand-new café in a poured concrete building while sitting on a chair designed to look "modern"? I hear that ramen shops are very popular these days in New York and Paris, and I have no idea what ramen shops look like in countries with very different food cultures, but at least in Japan, no one imagines that a beautiful, austere ramen shop will produce a mouthwatering bowl of noodles. The kind of joint that gets your mouth watering is in a wooden building, now weathered with time. The charcoal ink calligraphy on the white のれん noren, or doorway curtains, has faded from repeated washings, and the stubborn oil stains on the well-worn tables and chairs that defy scrupulous cleanings only heighten the shop's appeal. The menu items, handwritten on strips of age-yellowed paper affixed to the walls—who knows when—appear to have been there forever. If a designer, fond of stripping everything down to its bare essence, were to attempt to renovate this kind of shop into something "modern," all would be lost. Ramen shops have their own intrinsic standards that have nothing to do with Western fashions. Customers visit ramen shops, not for their conceptual beauty, but for the "sizzle" that appeals to the human instinct. Ditto for 居酒屋 izakaya, where people unwind at the end of a day over reasonably priced drinks and small plates all across Japan.

The 民芸 mingei folkcraft movement that Muneyoshi Yanagi championed from the 1920s onward in response to the onslaught of Western modern design was an important development that spotlighted the implements of quotidian

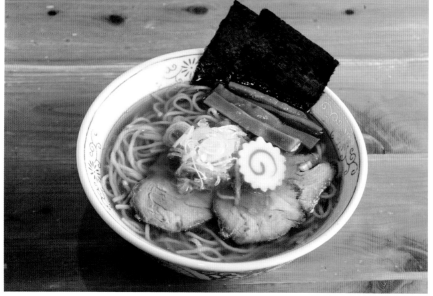

Japanese life. But I propose that we take a closer look today, following our openhearted instincts, at the spaces and things that have been around forever, neither remarkable nor especially beautiful, to recognize the merits of an authentic Japanese aesthetic. In fact, whenever I escort visitors from abroad to a timeworn, tasty ramen shop or izakaya, they exclaim their delight: "This is exactly the kind of place I was hoping to find!" But neither native Japanese nor our international guests who all instinctively adore these "sizzling" spaces can see the design in such spots, mistakenly believing that design can only be found in fashionable cafés. I want to show the world an authentic Japan, not just our overhyped, superficial, spectacular beauty. And design has always been essential to that authenticity.

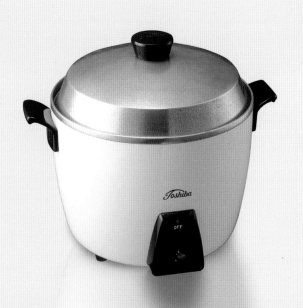

TO DESIGN OR NOT TO DESIGN

Some things are best just as they are and don't need much design at all. In fact, most things can be perfectly well designed without details that call attention to themselves. Nevertheless, if you approach design, either as the client or the designer, with the assumption that more design is always better, you will inevitably feel compelled to design something all over again. Few projects are approached with the understanding that design also means acknowledging that something is perfectly fine as it is and requires no more design, with the truly unfortunate consequence that even outstanding designs that should be left as they are continue to disappear from our lives.

Toshiba released the first automatic rice cooker in 1955. Its simple, functional design was stripped down to essentials, but after that, as Japan's "economic miracle" accelerated, we saw floral-patterned rice cookers or excessively round rice cookers, leading to today's multifunctional rice cookers, many of which are unnecessarily heavy and concocted to suggest luxury. Surely there's room in the market for a

high-function rice cooker that doesn't have some "image" tacked onto it, but they are hard to find. Simply put, there are very few designs that haven't been designed.

Let us also consider the design of the ubiquitous refrigerator. Are we actually comfortable spending time in a kitchen where the refrigerator is forever proclaiming, "I'm here! Look at me!" All we ask of a refrigerator is to blend into our lives and perform its functions. Frankly, there's absolutely no need for them to be conspicuously designed. And yet we find refrigerator doors sporting mysterious curves or accented in garish colors. Very few refrigerators promise an unassuming presence, and most have been adorned according to the self-serving rationales of manufacturers to promote their brand identity. A surprising number of manufacturers believe that, by definition, design means tinkering with ornamentation. Unfortunately, when talented in-house designers, who appreciate the essence of design, present brilliant designs that hardly *look* designed, they are disparaged.

We certainly don't want refrigerators to be less than they should be, but we also don't want them to be any more than that. It's just as important for objects to be discreet as it is for people. Except for when we're getting food in and out of the fridge, we want it to quietly disappear. Depending on the kitchen, the refrigerator can just be built into a wall. Of course, a refrigerator is a machine that can malfunction, but as long as you've planned for its replacement, there should be no problem. This thought process is precisely the first step in design. Design isn't just about adorning appearances. What we should really focus on is the fact that the fundamental design of a refrigerator is its function—chilling food, quietly, persistently, twenty-four hours a day.

QUESTION THE OBVIOUS
Max Factor fec. (1986)

My concept for this makeup line was to fuse the warm
contours of an ellipse with the cold material of aluminum,
while honoring Max Factor's origins as a makeup artist
for Hollywood icons. This was the job that inspired me
to introduce "sampling," already in vogue in the music
world, into my design process. The streamlined designs of
industrial designer Raymond Loewy, the rotating ellipses
of 1950s automobile taillights, the mishmash of past and
future in Terry Gilliam's *Brazil*—I selected such images from
magazines and other sources and, laying them out on a table,
sampled ellipses and applied a silver-hued aluminum.

The cinematic world of *Brazil* had an especially
profound impact on me at the time. I decided to envision
a lipstick that would appear in a movie. Resetting my brain
this way, I found I could imagine totally fresh images. This
was also when I began focusing on raw materials, just as
advances in coating technology were increasingly hiding
them from view. I wanted to use design to expand the
potential of raw materials, and reflecting on the feel of the

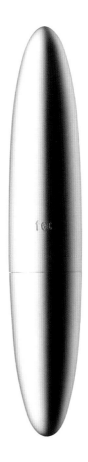

material led me to question whether lipstick tubes have to be vertical. When I realized that by taking advantage of aluminum's soft and malleable qualities I could design a slender, rotating ellipse shaped like a capsule floating in space, I asked myself, "Why do lipstick tubes need to stand up?" By deliberately questioning ideas long taken for granted, I developed my process, as with Nikka Whisky Pure Malt, where I identified the logic behind meaningless concepts and eliminated them.

SUPPLE THINKING

When I studied design in art school, it was drilled into me, however tacitly, that I should quickly discover my own artistic style and focus on developing it. This is why students who have forceful egos and are skilled at self-expression get high grades even while they are still studying design. This is one approach to teaching design, and it does encourage self-expression, but given the fundamental role of a designer, is it really appropriate to think of design as a canvas on which to create your own art? Isn't the essence of design to identify the social issues you need to address before you express yourself? Before you begin to depict something, question whether it should be two-dimensional or three-dimensional, whether it belongs indoors or outside, whether other factors need to be taken into consideration. Only after you have scrutinized every alternative and concluded that the best option is to paint it on canvas should you think about *how* to paint it.

Until I started working, I didn't realize that learning to design is more than developing your creativity, that it also

involves studying the social impact of design. There are rare cases when an artist's creation can function in society as design per se, but many perceive this as the rule rather than the exception. This misunderstanding causes real problems, as I discovered out in the real world. We should have been taught to consider social impact as part of our design education. A lazy curriculum that assumes students will eventually figure this out by exasperating everyone around them aggravates the whole society. Even if you devote all your time to illustrating because you like to draw, if you don't examine what your work means out in the real world, it won't be of any use.

After decades of working in the field, I am convinced that the definition of design is the skill to bring people and things together. In other words, good design is devising smart connections.

Let us, for instance, consider milk. Milk is a liquid, but it cannot be delivered in that form to many people. Its distribution entails many tasks, including a name, a logo, packaging, pricing, publicity, shipping, in-store displays, and even disposal solutions for the empty containers, each of which requires specific talents. Someone needs to select the right shapes and colors for the packaging to reassure consumers that the milk inside is safe to drink, and the milk has to stay fresh while it is transported from farms to factories and poured into containers for delivery. The former is visible to the consumer; the latter is not. If delicious milk is packaged in a distasteful container, then the connection, namely the design, is inferior. If money and time are wasted in the transportation process, then the system engineering, namely the system design, is bad.

Musing on another example, letters are what render words legible, and words have definitions, so various fonts

exist to accurately convey those meanings. Fonts are letters that have been deliberately designed. Typography brings authors and readers together. This process requires people who invent characters and people with the ingenuity to use those inventions by selecting the most appropriate font. Both skill sets can be considered design.

Let us also consider the chairs we sit upon. They exist to accommodate the human act of sitting. A chair is what connects a person and the act of sitting. The variety of forms provides a range of comfortable poses, but each chair serves as the bridge between people and the act of taking a seat.

As you can see, design brings together people and all things.

Connecting people and things means coming up with a unique approach each time. Maintaining the flexibility to respond to every project with a fresh strategy requires a supple thought process, rather than a single signature style. But such a supple process is not immediately recognizable to a third party; it remains faceless. I imagine it's comforting to have a unique style you can always return to like a homing instinct. Not having a specific place to return to can certainly cause anxiety. This is why people gravitate to a specific identity. They assume it will help establish their name.

Nevertheless, it's important to know that relying on a signature style means narrowing your options. To make

an extreme case, if you declare you are a round person, you will only be offered round jobs. If you proclaim that you are a red person, you will only get red jobs. Life is as richly transient as nature. If you stubbornly refuse to change, to live your entire life as round or as red, that is your prerogative. But there is no point in being inflexible. Design is integral to every human activity and a part of everything. Should we really be teaching aspiring designers that their only option is to develop a personal style?

It has only been a hundred years since people began exploring modern design. And computers weren't readily accessible until thirty-five years ago, so the only way to show someone an idea for a design was to draw it. Designers had to be good at drawing. If you couldn't depict your idea well, people just assumed you were a bad designer. This remains true today, and when I was a student I studied sketching obsessively, so I'm not disparaging that skill.

What does it mean to draw? Paintings have long been a framework for expressing individuality. The job of designing objects and things, determining how they will function in the lives of many indeterminate people, should require an objective perspective, but it also necessarily involves drawing, a means of self-expression. This was an inevitable development. But what is the result? You wind up designing things that please yourself. As you sketch, your drawings keep making their way toward your personal taste. Of course they do. In a word, you design subjectively. And then you convince yourself that this is your style. The public further validates your taste, and if that brings you fame, good for you. The reader may even wonder, *What's wrong with that?*

This is how we have wound up today with designers who think it really doesn't matter that design is a hodgepodge of the objective and the subjective. I am not condemning subjectively driven design; rather, I'm saying we should carefully deliberate the best approach for each project, after we have determined the difference between the objective and the subjective. I believe this confusion persists to this

day, causing resentful sniping, such as, "Designers get to do whatever they want. They have it made." But now that the role of design is clear, the essence of design can never be about expressing your personality.

I doubt anyone wants to become a cipher, pounded like so much clay into new shapes over and over again. Given that we've all been taught to value ourselves, I can't leap to the conclusion that that's a good idea. Nevertheless, if you can let go of your belief that you have to have a distinctive style, you'll soon find out that no matter what you do, you will remain you. Even if you discard the self, you are still all there. On every project, you need to determine the task at hand and focus on that. As long as you maintain a supple thought process, even if you set yourself aside to incorporate others' ideas, you'll never lose sight of yourself.

Supple thinking does not mean surrendering to prevailing ideologies or blindly following the pack, and it certainly doesn't mean pandering to trends. It means seeing your

situation as objectively as possible and positioning yourself
to respond to it. In the language of the life sciences, becom-
ing like stem cells, with the potential to develop into the
cells of any organ. Stem cells have no individual will but are
driven to develop into whatever shape the body requires of
them. To use supple thinking is to become what you should
become, using your rational judgment, without being swept
up by trends: not doing whatever you want, but doing what
you should. In fact, supple thinking transforms what you
should do into what you want to do.

Having your own personal style is an effective way
to gain recognition, but what are the consequences of a
self-conscious style? You wind up hostage to your own
roundness or redness as well as to others' preconceptions
about them. You wind up agonizing over whether to
protect your round style or destroy your red style. Is this
real freedom? If you only do whatever you want, you wind
up clipping the wings of your own potential. In fact, the

HIROSHIMA
APPEALS
2015

stronger your convictions, the more you should consider eschewing a set approach and a personal style.

These are the ideas that I have mulled over the course of my career and experiences in life. Of course, some projects demand that you stick to a specific approach to get to the bottom of an issue. And when I start digging deep, I tend to get obsessed. *Why is this done this way? What is going on here?* I try to approach the essence of a project by delving into each question as it occurs to me. When we are obsessed by something that appeals to us, we throw ourselves into it, leaving our self behind. You can't complete a job remaining obsessed without returning to an objective approach, but I think that becoming obsessed with something may be helpful to supple thinking. How can you possibly design anything without initially becoming obsessed with it? Even traffic signs, for example, require an investigation of what, where, and why. I imagine that the efficacy of a design based on an obsessive investigation will far surpass that of a design based on a less thorough approach—but only after you have removed all traces of you.

ISSEY MIYAKE

DO DESIGNERS REQUIRE TASTE?

People in the design world like to say, "Design requires taste." This not only sounds like there are two types of people, with and without taste, but also as if only special people come equipped with taste. But show me work that doesn't involve taste. Is there anyone in this world who doesn't have taste? I have always questioned this aphorism. Is it right for designers to sell themselves on taste, when taste is inherent in everyone?

In Japan, even half a century ago, the profession of design was barely understood. My father also worked in graphic design, and when he presented clients with a bill, they would often point to the Design Fee line item and ask, "What is this for?"

Let's reframe the relationship between a designer and taste. Ideally, a designer is someone with the talent and acquired skills to deploy their taste, to transform what they sense into something useful to the world. Design doesn't require unique professional skills, but it should cleave to

a quotidian perception of the world. All the more reason why designers have a responsibility to translate their ideas into words that others can understand. Saying an idea is "sort of cool," or assuming a client doesn't need it all spelled out, is no longer acceptable. If you think about it, this is a wonderful development. Although there remain many misperceptions about design, now that society assumes design is a necessity, at least designers are no longer considered extraordinary beings.

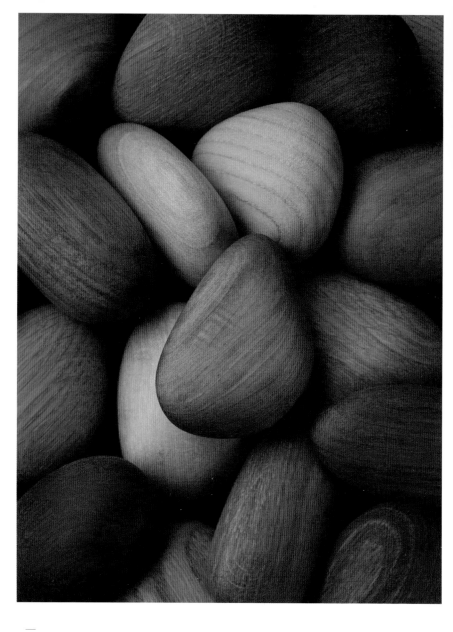

WOODEN STONES
(2010)

Takayama, nestled in the mountains of Gifu Prefecture northwest of Tokyo, has been renowned for the wooden furniture handmade by shokunin craftsmen for centuries. The Takayama furniture workshop Kijiya asked me to design a wooden stool and released the Kamachi Stool in 2009; you can still custom-order it today. While designing it, I visited their studio and encountered a machine that can shape wood into a three-dimensional object based on 3D data from a scan. The only way to carve curves into wood had been to shave it by hand, but by that time, computers had started entering the world of furniture making. Today, this technology is taken for granted, but at the time, it was still unusual, especially in modest woodworking shops.

Seeing the machine deeply inspired me. At the time, I was interested in bringing to life preexisting shapes, or formations created by nature, rather than dreaming up my own. Whatever forms my inadequate brain could conjure must already exist, somewhere in the world. Surely it was far more worthwhile to seek out a shape formed by the

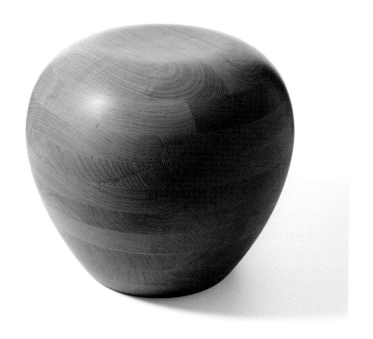

whims of nature and put it to use in people's lives. This concept culminated in the logo that I designed for the Kyoto University of Art & Design in 2013. I created this symbol by releasing single drops of charcoal ink from a certain height onto paper and letting them burst however they wished. The process of letting hundreds of charcoal ink drops fall as they may and then selecting the best silhouette was akin to the world of 書 *sho*, charcoal ink calligraphy. That is to say, you don't control the final outcome. Bleeds and blurs are integral to sho, and the final contours of the characters depend on the flow of charcoal ink seeping into the fibers of the 和紙 *washi*, handcrafted paper. What interested me at the time was design predicated on deferring to nature in the creative process.

In this approach to design, the stance is not "I will devise the shape," but rather "I am bestowed a shape." It also reflects the Asian spiritual concept of 自然 *shizen*, nature, represented in Japanese by the two characters that mean "of itself, as it should be."

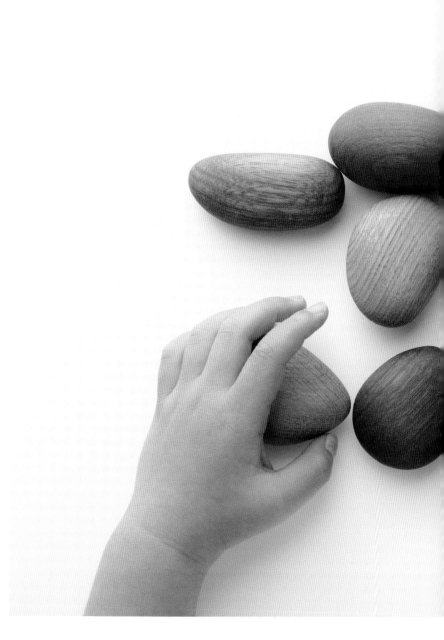

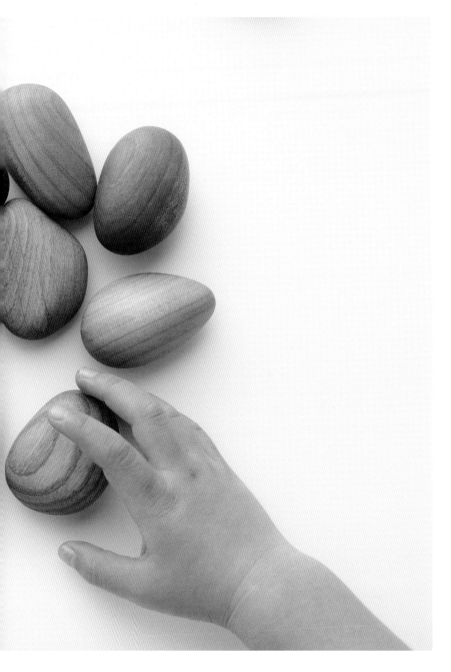

I encountered the wood-shaping machine just as my interest in this approach was growing, and it occurred to me that this machine could create natural shapes out of wood. Heavy stones and lightweight wood. Geological strata in stones and rings in trees. The images merged in my head, and right then and there I asked the operator if the machine could shave wood based on 3D scans of stones. He said, "Yes, that's possible." My heart skipped several beats. I instantly envisioned children arranging wooden stones, playing with these child-safe toys. We went into production soon thereafter and started by gathering stones in nature and choosing the right ones. The surface of the wood, shaped like the real stones' 3D data, was still a little rough. They needed to be buffed by human hands and then stained with a child-proof oil—in case children licked the stones—in order to keep them smooth.

I created these wooden stones for youngsters to figure out on their own how to play with them. They come with no instructions. They can be arrayed into faces or piled up into towers. They're light and safe, and the wooden grain on each stone is unique. Today, as more and more children play with digital devices, the need for such "primitive" toys that draw out the human imagination is only growing.

EVERYTHING IS DESIGNED

Today, most people would be surprised to learn that according to Japan's Nippon Decimal Classification (which specifies how libraries and bookstores sort their books), graphic design is categorized with painting. But more than half a century ago, when the advent of personal computers was beyond imagining, graphic designers drew letters and created poster art by hand. And before illustration was established as a profession, artists were tasked with such work. In the late nineteenth century, Henri de Toulouse-Lautrec was commissioned to create lithographs, to be printed up as posters advertising cafés and cabarets. Like so many Impressionist painters, Lautrec was profoundly influenced by the 浮世絵 *ukiyo-e*, "floating world" woodblock prints, of Japan's Edo era (1603–1868). Today, ukiyo-e prints are exhibited as major works of art in museums, but they are mostly woodblock prints of multiple editions as opposed to original works of art, basically the flyers of their time. The ukiyo-e prints depicting fashionable young women, popular 芸者 geisha, professional entertainers, and the stars of the

Kabuki stage were essentially celebrity photos, and you can draw a straight line from ukiyo-e prints to graphic design. Further back in time, during Japan's Heian era (794–1185), calligraphy and images were seamlessly integrated in the same visual space, comparable to layouts for the pages of a contemporary magazine. And so, historically, there has never been a clear distinction between painting and graphic design.

After Japan was defeated in World War II, when mass-produced goods and new cultures and ideas poured into the impoverished country from America, many Japanese unquestioningly associated them with images of a beguiling lifestyle. Through these goods, the very picture of abundance, Western design inevitably seeped into Japanese daily life, permeating it. Japanese people turned away from unadorned things to focus on the shiny packaging decorated with floral and other patterns, seeing in them a way forward into a bright future, in stark contrast to the harsh, dark, food-deprived years of war. There is no question that as Americanization rapidly made its way across Japan, there was a time when her citizens turned their collective gaze solely toward the decorative aspects of design. It is impossible to overestimate the shocking impact the vibrant colors of packaged goods imported from America had on Japanese people at the time.

As a consequence, the Japanese public imperceptibly began equating design with decoration. In other words, they concluded that a floral pattern = "designed," and unadorned = "not designed." Of course, there is also a history, well documented in books and exhibition catalogs, of the product and graphic designers and architects of that era who, responding to this mistaken perception, diligently strove to highlight the essential meaning of design. In fact, the original goal of the design community that emerged

The concept of design until now

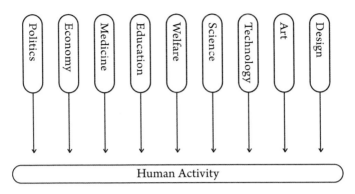

The concept of design from now

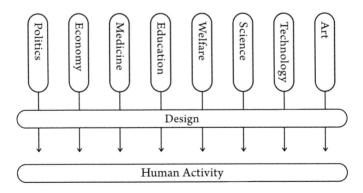

in Japan in the early 1950s was to promote awareness about design. Nevertheless, the prioritization of Japan's economic miracle engulfed the best intentions of this small group of dedicated individuals. Any serious examination of design was set aside as products flooded the country in an era of turbocharged prosperity, spurred on by a cornucopia of technological innovations.

With the phenomenon of marketing added to the picture, manufacturers rolled out products corresponding to consumers' statistically proven desires and rushed headlong into indiscriminate selling. It is also true that even under such conditions, Japan created some innovative products, but their number was overwhelmed by the staggering consumption of mostly indistinguishable stuff, mass-produced solely for profit. The decorative approach typified by eye-catching floral patterns was also cleverly deployed for the sole purpose of boosting sales, reaching every remote corner of Japan.

There is not a single object, nor a single human endeavor, that does not involve design. From the organization of information to the mechanisms of electoral representation, from the medical equipment upon which human life depends to computer interfaces, from city planning for disaster zones to the letters and numbers we read every day, from traffic lights to the sounds and lights emitted by our smartphones, everything has been designed. In this light, it appears to me that design is like water. Like water, it is sometimes visible, often invisible, but always essential to our lives.

When someone hears the word *design*, they imagine a range of things that are cool or fashionable or sophisticated or かわいい *kawaii*, cute, or spare, but that is just one small aspect of design. Try envisioning design as water. Water is

indispensable to human life, connecting us to our environments in visible and invisible ways. It can cause disasters like tsunamis (and so can design when it is uncalled for or when it tries to add nonexistent value), but it can also materialize as a rainbow, radiant in the light of the sun. Just as water makes every phenomenon possible, design is an essential component of every human endeavor.

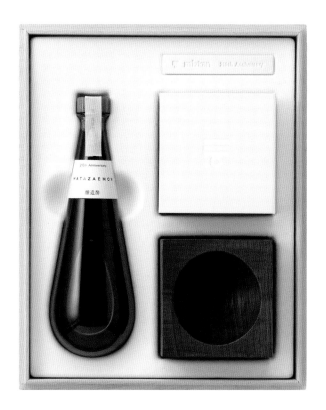

MIZKAN'S 210TH ANNIVERSARY PROJECT

(2013)

Mizkan began producing rice vinegar more than two centuries ago, and their vinegars remain popular today. When they asked me to create a gift box of vinegar to commemorate their 210th anniversary, I hit upon the idea of a round-bottomed vinegar vessel that sits in a wooden base. The cover of the wooden gift box is inscribed with the company's logo and the founder's signature, reproduced in charcoal ink, to convey his enduring legacy. Long after the last drop of vinegar has been savored, the bottle can serve as a lovely vase.

This bottle is shaped like a teardrop, but my original idea for it was a drop of water. Water, a liquid, gives birth to life, and vinegar can also be traced back to water. A bottle in the shape of a single drop of water would symbolize Mizkan's approach to making vinegar as well as their gratitude to the natural environment. But a drop of water has a circular bottom; such a vessel cannot stand on its own. And if you flatten the bottom, you squander the appealing contour. That quandary led me to use wood to create a

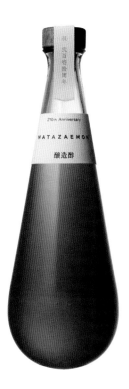

base for the round-bottomed vessel. This was a limited anniversary edition, so I deliberately proposed a shape that would have been too costly for their product lineup. Seventy percent of Japan's landmass is forest, but because of an influx of cheap imported lumber, there is plenty of spare domestic wood. The idea to use Japanese wood for this project also emerged from my thought process. And wood is soft and gentle in contrast to inflexible glass, providing the perfect support.

Ultimately, the package consisted of an unusual round-bottomed bottle nestled in a wooden stand. I designed the mouth of the bottle without a screw thread and made the wooden base a simple square so it can be reborn as a vase for flowers and plants after the vinegar has been consumed. I hoped my design would subliminally encourage people to want to use it to display flowers instead of throwing it away. *Affordance* is a design term for the properties of objects that show users how they can be used. When design is restrained to hodo-hodo, it can afford the user the desire to repurpose it.

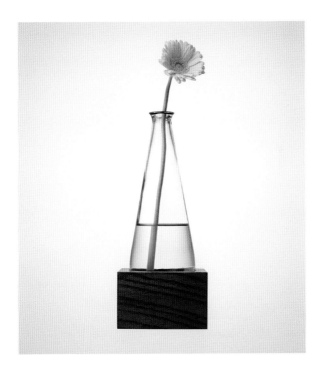

THOUGHTFULNESS

It should go without saying that we undertake every job, every task, for what lies ahead, whether a moment, a year, or even one hundred years into the future. For every undertaking, we must think through what we need to do now and implement it on behalf of the future.

When someone prepares a delicious meal, their job is to imagine the happiness it will bring to the person who eats it; when a physician provides health care, their job is to carefully consider every course of treatment, including natural remedies, and implement the appropriate care so patients can live their lives in the best possible health. In other words, regardless of your expertise, you cannot meaningfully accomplish any task if you are not able to anticipate what lies ahead. An inability to think ahead can have dangerous consequences. Most of the calamities that make the headlines are caused by deficient imaginations.

The same is true of design, for no matter how many beautiful shapes you devise, no matter how perfect the lines you draw, unless you have fully grasped your situation and

imagined the future, to understand the task set before you now, your expertise will be of no use. A mistaken read of the future can bring misfortune to many. That being said, no matter how carefully you consider what lies ahead, there is no such thing as perfection in human endeavors. Nature does not exist to serve human purposes, and there will always be unpredictable developments, such as natural catastrophes. But that is no excuse for not trying; we need to constantly question whether we are taking the right approach, precisely because it will never be perfect.

For example, if you find a large rock fallen on the side-walk, it goes without saying that you will move the rock aside, mindful of the frail pedestrians among the countless women and men, young and old, who will pass by it. If you do, no one will know there ever was a rock, and everyone can safely walk on. This is also an act of imagining and taking initiative. If you can only consider your own interests, instead of removing the rock, you just might stumble on it yourself.

It's important to get into the habit of always paying attention to your given circumstance. If you have to think about it, it's too late. Being thoughtful is no doubt exhausting for anyone unaccustomed to such consideration. But if you make it a habit, instead of getting tired out, your body will spring into action. I think back to when I rode a crowded train. I noticed someone who, just before the doors opened, saw an elderly person preparing to board and discreetly rose from their seat, avoiding the impression they had deliberately vacated it, and stepped aside to reach for a strap handle. What I remember is their remarkable discretion, but a youngster, oblivious to his surroundings, took advantage of it, grabbed the seat first, and refused to give it up while the elderly passenger stood nearby. As I observed his facial expressions and entitled attitude, I couldn't help but feel sad,

wondering how long the youngster planned to continue his self-centered, inconsiderate lifestyle. I mused that, in any case, I don't want that kind of person to become a designer. He is entirely unsuited to the job. In fact, his approach to life is unsuited to any job, let alone design. As I noted, all tasks begin with imagining what lies ahead. Every project that involves design involves designing for the future. What matters most is to thoughtfully envision the future desires and needs of the user. We should apply this to our daily lives as well as design.

DESIGNING FOR TELEVISION
(2003-)

In the summer of 2002, the Japan Broadcasting Corporation (NHK) asked me to join the creative team developing an educational TV series for children. Titled 「にほんごであそぼ」 *Nihongo de Asobo*, *Let's Play in Japanese*, it was slated to start broadcasting the next spring. When they hired me as the art director for the series, all they had agreed upon was that the daily episodes would last ten minutes and that the subject would be the Japanese language. The renowned Japanese language educator Takashi Saitoh also joined the team, and we frequently met with the NHK staff to discuss what we should be doing now for the future of Japanese children. Our fundamental goal was to imprint the wonders and pleasures of the Japanese language while the viewers were still children who could have fun playing with it. I realized that because of the proliferation of nuclear families with fewer elders who can pass on the richness of the language to children in Japanese households, the role of television also needed to evolve.

にほんご
であそぼ

Nineteen years later, *Nihongo de Asabo* is still broadcast early every weekday morning. It explores the Japanese language from a range of approaches: the oral transmission of well-spoken Japanese; the visible contours of our language; its spellbinding rhythms; the beauty and mysteries of the written language; the language of our traditional performing arts; and new words and phrases. All presented with a universal appeal that the children's parents can also relate to. The episodes are a pastiche of word games, folk songs, snippets of Noh and Kabuki plays—any and everything to impart the wide range and subtle nuances of Japan's linguistic heritage. In television programming today, it's only on shows created for children that such experimentation is possible. Designing books, playing cards, and other merchandising to complement the series, we constructed the world of *Nihongo de Asobo* through television images and objects in the real world.

All of the text that appears in the series uses the original *Nihongo de Asobo* font that I created for the show. By developing and broadcasting a font exclusive to the series, we are also imprinting specific images of the Japanese written language on children's memories. In Japanese, there are subtle but crucial differences in the spoken and the written languages, rooted in the literary, poetic, and calligraphic traditions dating back to the eighth century, the complex integration of three "alphabets"—ひらがな *hiragana*, カタカナ *katakana*, and 漢字 *kanji*—and the profusion of its onomatopoeic expressions.

My first thought when I joined the *Nihongo de Asobo* production team was that, just because it's a program for children, I didn't want to create an infantilized world. For starters, little kids can't distinguish between what's childish and what's grown-up. For youngsters, most things in their

わ ら や ま は な た さ か あ
を り 　 み ひ に ち し き い
ん る ゆ む ふ ぬ つ す く う
　 れ 　 め へ ね て せ け え
　 ろ よ も ほ の と そ こ お

lives are happening for the first time. I've always been dubi-
ous about the postwar Japanese trend to give children things
that adults consider kawaii, before they have formed their
own ideas about things. You could go so far as to say that I
hold it in contempt. I always believed it's the job of adults
to supply impressionable, openhearted children with what
we ourselves truly appreciate and that this is critical to their
education. I proposed this approach at our first production
meeting, and we all agreed. It grounded the direction of
the entire program.

Based on this reasoning, and given that *Nihongo de
Asobo* is a program about the Japanese language, I resolved
that we should make the effort to develop an original font
for the program. Instead of choosing from existing fonts,
we would create letters unique to *Nihongo de Asobo* and
integrate them into its core identity. Previously, most tele-
vision programs, including those for children, had just used
existing fonts for the text graphics known as *chyrons*. I didn't
want to cut corners on the assumption that youngsters
"wouldn't know the difference."

And although the program is intended for children, the 歌舞伎 Kabuki, highly stylized classical drama-dance performances, 狂言 Kyōgen, classical comic relief performances, and 文楽 Bunraku, classical puppet theater, actors who appear are first-class stars who tour the world, and the program's costume and studio set designers, voiceover actors, and illustrators are all world-renowned. This was only possible because we had all agreed from the start that we wanted our young viewers to have a first-class experience of everything. Nineteen years have passed since the show started, but to this day, I remain part of the production.

A ROOFTOP OF ONOMATOPOEIA
(2017)

The Toyama Prefectural Museum of Art and Design asked me to design a playground for children and their families to enjoy together on the roof of their new museum. But they had one stipulation: that I relocate and incorporate their local ふわふわ Fuwafuwa Dome, a cloud-shaped air-inflated trampoline that kids love to bounce, pounce, and cavort on. *Fuwafuwa,* fluffy, is one of more than four thousand mimetic sounds and ideophones in the Japanese onomatopoeic vocabulary. They viscerally express a wide range of sensations from the natural world, such as rainfall, sunlight, and animal expressions, along with human sensations, such as a heart pounding with excitement or the reluctance of a dawdling child. They play a crucial role in everyday communication.

Taking a hint from the Fuwafuwa Dome, I came up with the idea for a Rooftop of Onomatopoeia. Instead of designing playthings and equipment first, then naming them as an afterthought, I chose whimsical onomatopoeia like ぐるぐる *guruguru*, going around in circles, ひそひそ *hisohiso*,

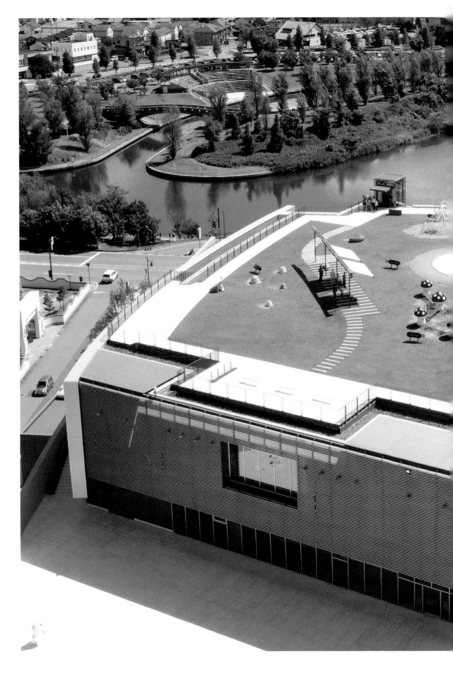

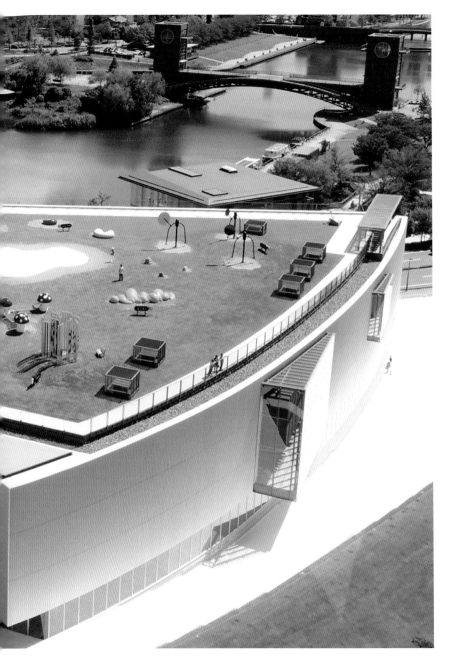

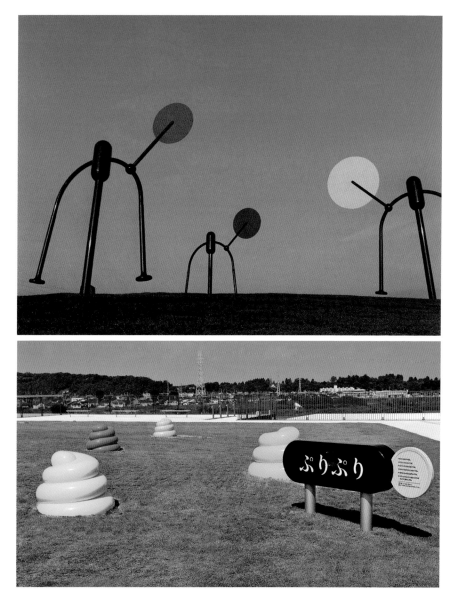

whispering, and ボコボコ *bokoboko*, bumpy, to inspire the play area facilities. To children, the borders among playing and learning and art remain invisible. I designed the playground so that on the roof of an art museum, children can marvel at a mountain range in the distance, stare up at the clouds, and conjure their own original onomatopoeic expressions.

ほしいも学校

ほしいも学校　校歌

一、踏みしめる大地から、
生まれる星がある

ほしいも　ほしいも
それはキラキラ光る

希望の星……etc.

作詞　日影良三

DESIGNING TERROIR
The Sundried Sweet Potato School (2007)

Sundried sweet potatoes are the indigenous winter food of the Pacific coast of Ibaraki Prefecture. That's where 80 percent of Japan's sundried sweet potatoes are produced, following the ancient, laborious, handcrafted process, dependent on the climate and plentiful sunshine. The prefectural chamber of commerce asked me to develop products highlighting the benefits of sundried sweet potatoes, to revitalize their regional specialty. As I listened to their presentation, my thoughts turned to the Design Anatomy exhibit series I launched in 2001. I used those exhibits to dissect mass-produced consumer products we all take for granted, such as chewing gum, Instamatic cameras, and milk, from the perspective of design. I peeled back the surface layers of things we think we already know, to reveal just how little we know about them.

As soon as I imagined investigating every aspect of sundried sweet potatoes, the idea for a school came to mind. Not a school with a schoolhouse, but a collective called a

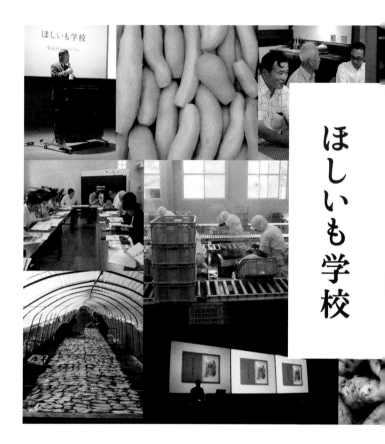

ほしいも学校

school, where we could investigate this artisanal delicacy, hold workshops, and, of course, develop products. The school would be a platform that could be used for anything. Besides, a school for grown-ups could be fun. And we would create a thick book about the anatomy of sundried sweet potatoes and sell that together with the actual product. The instant I had the idea to sell the book and the food together, I could visualize it: reading the book while eating sundried sweet potatoes with your fingers and learning about them.

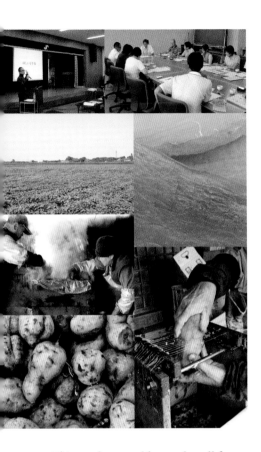

This product would appeal to all five senses; you could hear the sound of turning pages and smell the aroma while savoring the food.

We were analyzing everything from the sunlight pouring down from the universe to photosynthesis, from the dry sea breezes of winter to the local stratum, soil qualities, and water, from selective breeding and the history of sweet potatoes to the intestinal microbial activity in the human stomach, even the resulting human gas and waste. So we

visited many laboratories. I no longer recall how many places we called upon, whisking to and fro, but the satisfactions of embarking on an unprecedented project through sweet potatoes felt like opening a door into the universe.

We completed *The Sundried Sweet Potato School*, the hefty book packaged with sundried sweet potatoes, in 2010. Soon thereafter, following the Great East Japan Earthquake and nuclear power plant accident, we convened a symposium about radiation and sundried sweet potatoes in order to promote better understanding about the sun-drying process. Next, I proposed the idea of a celebration, and we soon launched the annual Sundried Sweet Potato Festival. Given the proliferation of sundried sweet potato production across Japan resulting from technological advances and product improvements, we hosted the World Sundried Sweet Potato Convention to promote Ibaraki as Japan's production hub to the world. In 2019, thanks to the cooperation of many people, we even founded the Sundried Sweet Potato Shrine.

My intention for this project was to cultivate the strengths of the local residents. Instead of providing all the ideas and making them happen, I invited residents to participate so they could feel the project belonged to them and, as much as possible, move things forward on their own. And now, I believe we have accomplished this. This is another project in which I felt it was important for me to keep a hodo-hodo distance, without getting overly involved.

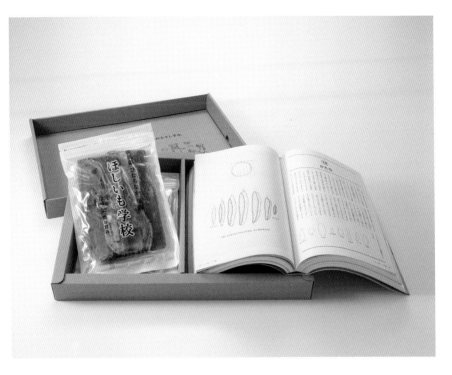

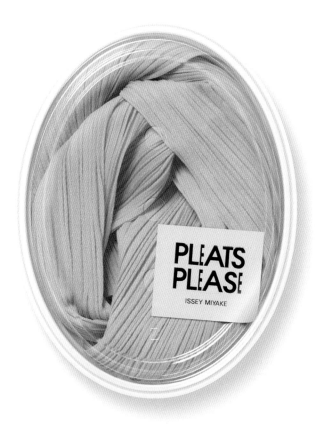

DESIGNING BASICS
(2005)

The essence of design is to thoroughly understand a project and communicate it as straightforwardly as possible. That's what design is. If it's beautiful, design it beautifully. If it's compelling, design it to be compelling. If it's spare, keep the design spare. If you always hold fast to this unaffected approach, design can also serve as a litmus test for product development. In other words, if something designed with integrity doesn't lead to a strong product, you should reexamine its premise.

In the spring of 2005, I was asked to design four series of ads for the fashion brand PLEATS PLEASE ISSEY MIYAKE, to be featured in All Nippon Airways' in-flight magazine, *Tsubasa Global Wings*. By the time we had our first meeting, I already had the key word *everyday* in mind. PLEATS PLEASE was born of Issey Miyake's intention to reinterpret fashion as an everyday product. You could say Miyake was pushing his own envelope, the culmination of his experiences designing for countless Paris Fashion Weeks, the epitome of fashion as the extraordinary.

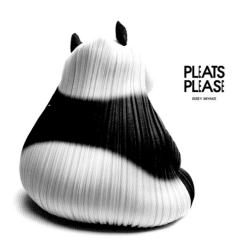

**PLEATS
PLEASE**
ISSEY MIYAKE

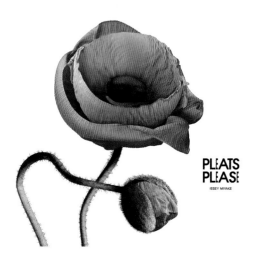

**PLEATS
PLEASE**
ISSEY MIYAKE

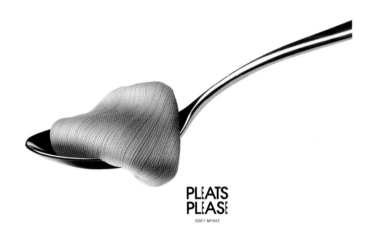

**PLEATS
PLEASE**

ISSEY MIYAKE

**PLEATS
PLEASE**

ISSEY MIYAKE

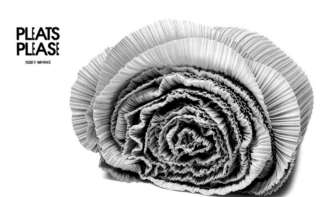

I got right to work borrowing some PLEATS PLEASE
clothes and handling them. They don't wrinkle when you
fold them. They're easy to store and wash, and rolled up
into little balls, handy to carry. In addition to their function-
ality, the exquisite alchemy of the fabric and the pleating
treatment complement the contours of the human body.
Plus, they're nearly weightless. I immediately understood
that they embodied a multitude of prerequisites especially
appealing to women. *Everyday, easy, mobile, scrunched-up.*
The words started circling my brain. They comprise the very
definition of convenience. There is a convenience store on
the first floor of my office's building, so I entered it in my
head. What was I looking for? In these situations, I don't
physically go to a convenience store. It's only in my brain
that a universal image exists that I can share with others.
Then I came across the bento boxes. The four key words
all applied. And you can see inside the transparent covers.
Inside these cases, you could show off the beautiful colors—
just like a tasty pasta bento. I submitted other proposals, but
this idea won out. When we actually searched for the perfect
plastic bento case, it proved elusive. So these images are
composites of close-ups.

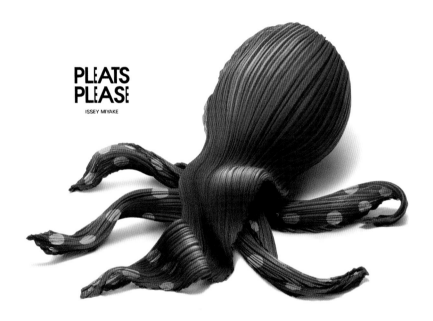

PLEATS
PLEASE
ISSEY MIYAKE

DESIGNING FOR ARTISTS

When I design an artist's book, I start by immersing myself in their art. Artists' books are better when there's no trace of me in them. How thoroughly can I erase myself? How much of the artist's intentions can I draw out? These are my primary concerns whenever I'm asked to design a book featuring another artist's work. Of course, it's different when I'm asked to collaborate with an artist on their book. It's important to understand this crucial difference. Am I participating as a designer or as an artist? This difference doesn't seem to matter to some designers, but it matters to me. For an artist, a book is part of their art. Which is why, ideally, an artist should view their own work objectively when making a book of their own art.

But they turn to designers because they *can't*. In other words, the designer should stick to being a translator. What's important is for the designer to understand the artist's intent—what the artist wants to communicate through the medium of a book—and elicit from the artist aspects of their work that they themselves aren't aware of. Just as

there are many ways for an interpreter to interpret the same word, every designer will interpret an artist in their own way. That is how a designer can express their individuality. Individuality should reside in a designer's approach, not in the work itself. The best artists' books reveal what the designer has elicited from the artist and leave it at that.

WHAT WE LOSE TO CONVENIENCE
(1989)

Japanese breweries began selling sake in 1.8-liter handblown returnable glass bottles called 一升瓶 *isshōbin*, which are slightly larger than a magnum of wine, in 1897, and sake has been associated with isshōbin ever since. An isshōbin is heavy, but the ritual of holding its neck in one hand while raising its bottom with the other to pour sake is enshrined in Japanese sake culture, one of its pleasures. Likewise, the much older tradition of pouring each other sake from 徳利 *tokkuri*, carafes, into おちょこ *ochoko*, small sake cups, while hardly convenient, is a ritual of respect and hospitality. It is an important form of communication passed down over the ages as tradition.

As life becomes more convenient, many things are lost without our realizing it. In the case of the isshōbin, it isn't just the physical sensation of holding it that is gone. As sake is sold in smaller, lighter bottles that are easy to pour from, we no longer engage in the rite of pouring for one another. Sake bottles become easier to carry and are recyclable, but they are not returnable, and the job of cleaning isshōbin dies

out. The distributors' task of reclaiming isshōbin ceases to exist. The job of hand-pasting labels onto isshōbin passes into oblivion. Jobs are lost, along with the balance inherent in specialized labor. Japan's sake culture, intertwined with people's lives and fostered over centuries, is crumbling without our even noticing. Convenience is destroying our entire society. What does it mean to savor sake? Isn't it time for us to consider that it's more than the taste in your mouth, that it's also inherent in the vessels, ceramics, tables, and spaces we consume it in? When I was asked to design a vessel for a sake brewery, I became obsessed with the deeper meaning of the humble isshōbin.

THE CONVENIENCE VIRUS

Contemporary Japanese life overflows with convenience. Our lives became relatively convenient during Japan's "economic miracle," from 1954 to 1973, when home appliances flooded the country. But since then, a whole new range of goods and services has been diligently innovated for evermore convenience. Some type of design is essential for such conveniences to reach people, so investigating how these commonplace products are designed can shed light on the mindsets and lifestyles of Japanese people today.

The relentless pursuit of money and convenience lingers in us like a virulent virus, despite the oil shock of the mid-1970s, the collapse of Japan's bubble economy in the early 1990s, the financial crisis of 2008, and even the Great East Japan Earthquake in 2011. No doubt this trend is not limited to Japan and is prevalent in urban societies across the globe. I would like to deliberately challenge our now-entrenched craving for convenience that we never questioned, so we can ponder what lies ahead for modern life.

It goes without saying that the different sources of energy that support our daily lives are profoundly connected to convenience. Our energy problem is invariably framed in relation to resources and technology, but if we examine the intentions and rationales of the human beings who consume that energy, we inevitably land on the vexing concept of convenience.

Where and how did convenience emerge? Even before the agricultural revolution that transformed many human cultures, human beings were already developing convenient tools in the Stone Age. Human behavior motivated by the deliberate pursuit of convenience has always been an integral part of our history, along with the development of the human brain, and is deeply embedded in human civilizations. I certainly understand why the human brain is driven to concoct even more convenience in our modern world, given the profusion of amenities yielded by the industrial and information revolutions.

Nevertheless, the problem is that nearly every convenience conceived in the modern era is inextricably linked to economic activity and exploited for individual profit. I would go so far as to say that we are surrounded by conveniences delivered to us by businesses. Proponents may argue that providing conveniences is a benevolent human endeavor that delivers services through things. However, their fundamental goal is to keep raising year-over-year sales numbers, and generally such logic is nothing but a fig leaf for making money. Our society is now driven by the human instinct to seek convenience fused with our measure of prosperity, now biased in favor of economic over cultural wealth. And underpinning this is the narcissism epitomizing individualism, born of a twisted interpretation of democracy and freedom, rather than an objective public discourse. Most

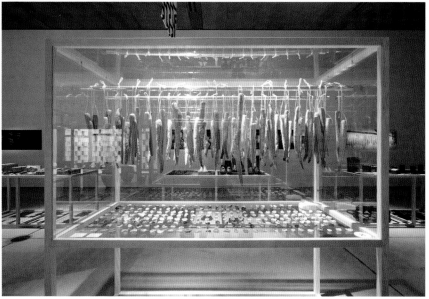

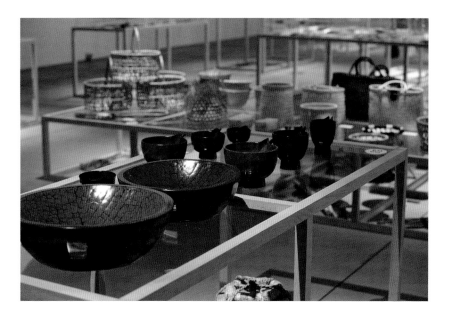

people, while sensing that something is awry, prefer to not pursue this, afraid that deliberately questioning the myriad conveniences—which are intentionally installed everywhere we venture and that now stain our bodies and our spirits— might be misconstrued as condemning civilization, the economy, or even human endeavor itself. It is no easy task to stop and reexamine the full significance of convenience.

But there is one good approach: Use the human body as the standard. What happens to human beings if they gorge on conveniences in order to avoid physical move- ment? The logic is simple, the answer obvious. When the body withers, it begins to die. To survive, the body must retain the flexibility to adapt to changes in its environment. Reexamining convenience through the benchmark of the physical bodies that shape us as humans may bring its future into perspective.

Taking a good look around, we can see that we have designed most modern conveniences to avoid moving our bodies. We are surrounded by conveniences designed for that. Flip a switch to make anything happen. A trip to the convenience store lets us one-stop-shop for basics. Stepping onto an elevator or escalator requires much less effort than climbing the stairs. Leave it to machines to clean our homes, our clothes, even our dirty dishes. Once humans started walking on two legs and our brains developed and acquired critical thinking, we also figured out how to take things easy. As thinking human beings, we are destined to engage our minds in the service of daily life. Faster. Easier to eat. Simpler. Warmer. We have been bestowed with a splendid talent to utilize our intelligence to improve our existence. But the irony of modern society is that using that gift to pursue convenience has taken a serious toll on our bodies.

What is the current state of the modern human body? Obesity, diabetes, and hypertension top an endless list of modern ailments, rising in inverse proportion to our decreasing physical activity. If we continue to disengage from physical activity, it will no longer be possible for our physical evolution to keep pace with the dizzying speed of increasing convenience. It would be one thing if our society were built on slower, deliberate, long-term change, but the ferocious speed of modern convenience is not premised on the natural pace of human evolution. We have no choice but to reconsider the very idea of convenience, based on how critical it is that we move our bodies.

In addition to the human body, the convenience virus has also debilitated Japan's cultural heritage. A review of the current state of Japan's traditional cultures reveals how convenience has ravaged the craftsmanship that was once integrated into daily life but now lies on its deathbed.

Lacquerware, dyed fabric, weavings, handcrafted paper, ceramics, and an endless list of everyday tools, painstakingly created for centuries, are disappearing from our lives as I write.

If a vaccine to counter the convenience virus were to exist, it could only be the habit of questioning the very idea of convenience. One example of an invention that naturally encourages physical engagement is the power-assist bicycle. It lacks the convenience of scooters that start moving with a turn of the grip and encourages riders to do some pedaling and move their bodies.

Another example close at hand is the mechanical pencil I always use whenever I'm designing. A wooden pencil involves the time and effort of sharpening, but one click on the mechanical pencil exposes a uniform width of lead. Instead of sketching lines on a computer because it's convenient, I use my hands and can experience the pleasing friction of lead on paper. And unlike when I draw on a computer, I don't consume electricity.

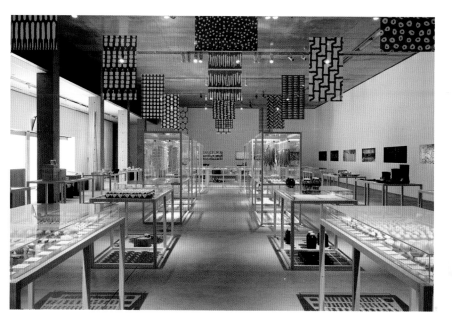

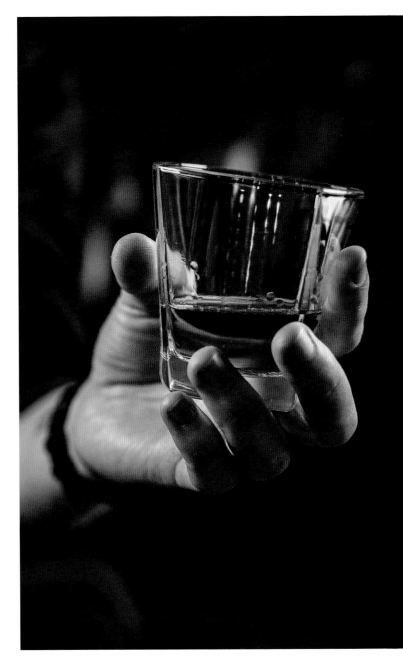

A LITTLE SPIRIT
(1985)

One year after Nikka Pure Malt proved successful, the
Nikka Whisky Distilling Company launched From the
Barrel, a 51.4 proof whisky with a robust character. What
bottle would best suit a big, rich whisky? I wanted it to be a
little spirit. Rich foods are more appealing in small portions.
The intensely flavored 塩辛 *shiokara*, fermented seafood,
which pairs so well with sake, looks delectable because it's
served in tiny bowls. It's possible that full-flavored foods
are served on small plates because we can't digest them in
large amounts, but it's just as likely that our memories of
those small portions trigger our brains to water our mouths
whenever we see something rich served in a small vessel.
The natural climate and mores of specific regions give rise
to their food cultures.

This subtle sensibility is exceedingly Japanese.
Powerful flavors come in small portions. Adhering to the
metaphor of a little spirit, I designed a square, short-necked
bottle. From the front, square bottles appear smaller than
round bottles of equal volume. I designed a very short

bottle cap, in the height then used for medicine bottles. This was before such caps were used for alcohol or perfumes. We left it unprinted to preserve its aluminum texture. The neck was so short it made pouring challenging and had never been mass-produced before. To persuade the client, I explained how the challenge of pouring sake from a tokkuri into a tiny ochoko fostered interpersonal connections. When the whisky first went on the market, we included a booklet the same size as the box, detailing an erudite history of the whisky. Whisky designed to be savored by the palate and the brain alike.

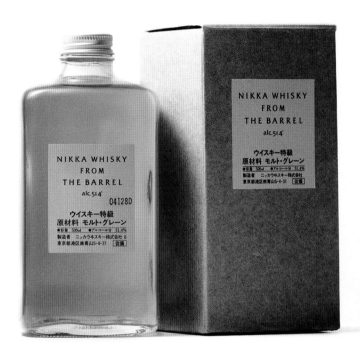

VALUE ADDED

Whenever I hear someone declare that "adding value" is what matters most, I find myself scrutinizing the speaker's face. This concept means adding an external value to something. I believe that, in fact, Japanese craftsmanship began to decline as soon as the idea that value can be added to something took hold. Is value really something that can be slapped on like a label?

If you pick up a stone from the street and use it as a paperweight for the papers on your desk, that stone has become valuable to you, but have you actually added to the value of the stone?

Herein lies the perilous sorcery of words. The stone remains a stone, even when it's placed on your desk; it just happened to be the right size for you to pick up from the street and use as a paperweight to keep your papers from scattering in a breeze. You have not added value to the stone. Instead, you have discovered a value in your relationship to the stone that was always inherent in the stone. It goes without saying that adding something is the opposite of

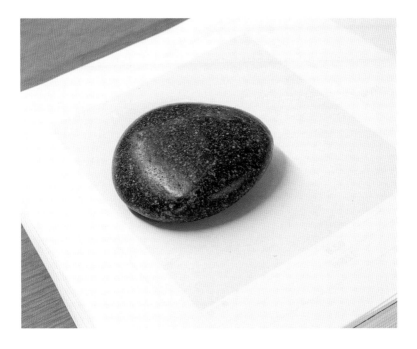

discovering something. Have you simply projected your convenience onto an object? Or have you summoned a purpose for the object by considering it for what it is?

When someone has the ability to draw out inherent potential, we say they are talented, including, of course, people who can draw on their own potential. But it's impossible to accurately assess the value of something that you simply slap value onto, without clearly seeing it for what it is. We do not call those people who thoughtlessly add value to something talented.

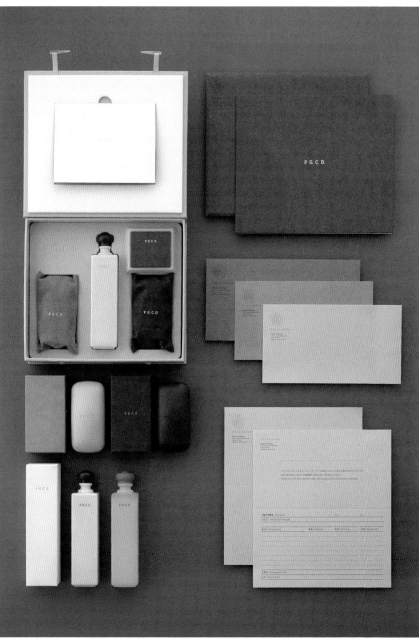

PACKAGING DESIGNED FOR MEMORIES

(2000)

P.G.C.D. was envisioned as simple, high-quality skin care, intended to return to the basics of facial cleansing and moisturizing. The three core products are daytime and nighttime soaps and a lotion. I joined the project as the designer during the development phase. The company's decision to market exclusively through mail order opened up possibilities not available for products sold in stores. When products are sold in stores, distribution costs, retail margins, labor costs, retail publicity, and enormous advertising costs must be added on top of the price of the product. There are no such costs in mail order, which allows for a lot of high-quality materials to be used to make the products. Plus, more care and effort can go into the packaging, the medium that customers will directly touch.

These products are targeted at consumers who have a wealth of experience with other skin care brands. Thus, the products are positioned as the final destination after trying many others. The concept is to reconsider the male-conscious approach to makeup that covers as much

of a woman's face as possible, to reveal that if a woman maintains the health of her skin, she is most beautiful in her natural state.

I designed the logo, soap, bottle, and packaging, as well as the graphics for the user instructions, business cards, letterhead, and magazine ads when P.G.C.D. first went on the market. Although it is a simple skin care system, the quality of each item had to anticipate the expectations of customers already accustomed to a range of high-end products. I was especially conscious of the feel of each item as a direct appeal to the consumer's sense of touch. Through our senses of sight and touch, packaging can evoke memories.

We all touch things from when we are babies, and we unconsciously remember those sensations. And when we touch something, we may also recall a similar feeling. We use the English word *silky* not to refer to silk but to describe the touch of something that feels just like silk. A sommelier is someone with a talent for conjuring seductive similes to detail flavors and aromas. When I'm designing for touch, I can't use words like a wine steward, but I want people to recall a pleasing sensation from the past and to savor the unique sensations of the product. The packaging for P.G.C.D.'s Coffret boxed set, which launched the brand, combines the qualities of delicate papers, the texture of a soft cloth, and the feel of cold glass to reawaken a range of memories in the mind of the user.

STRUCTURE AND SURFACE

Structure and *surface* are terms from the field of architecture, but they both involve design, so you could say one is structural design, and the other, surface design. Structure involves designing the pillar and planar structures and other functional mechanisms required to physically erect a building. Surface involves the texture and colors of its exterior, as well as doors, windows, walls, and all the elements a building requires after its structure has been enclosed.

Graphic design doesn't generally reference structure and surface. Compared to three-dimensional architectural constructions that must be built to physically stand the test of time, two-dimensional graphic design is not burdened by concerns about wear and tear. Designs printed on paper may wither and crumble, and the colors may fade, but they will not endanger human lives. Nevertheless, I believe that many aspects of graphic design warrant an awareness of both structure and surface. Just as architecture must consider the passage of time in the natural elements, graphic design should consider the passage of time in human memory.

How do people remember logos and product designs, and how do their memories evolve with time? When you don't see something for a while, that memory is stored in the brain, seemingly forgotten. But if you can recall it when you see it again, it means that memory survives. Yet when you are asked to make a drawing of even something you are familiar with, it's not so easy. Individuals' drawing skills may vary, but it is also proof of the unreliability of memory. However frequently consumers are exposed to logos and packaging, they must be easy to remember and designed to compensate for the fragility of human memory.

When designing logos or products, the goal is not a more or less beautiful design, but rather a design inspired by an entirely original structure that will increase its chances of surviving in human memory. This requires simplicity. The human brain is certainly capable of retaining complexity, but inside a store, where customers are bombarded with information, the chances of complexity surviving are greatly diminished.

The structure of the Meiji おいしい牛乳 Oishii Gyunyu, Tasty Milk, carton is a blue cap atop a white body with the product name in chunky font vertically aligned in the traditional Japanese style. For Lotte's XYLITOL chewing gum packaging, the logo and product name in white are set against a bright green background. These structures are both exceedingly simple, and although the information provided in smaller fonts has evolved over time, the basic formats have remained unchanged for decades. This is why the components of these designs have survived in people's memories as unique.

Approaching graphic design as the two distinct layers of structure and surface is also useful in branding. This approach can surely play a role in promoting Japan to the

world. A structure founded on a clear concept can support a range of designs. In other words, a lineup of fascinating content is insufficient to convey the authentic Japan rooted in its history. We must begin by creating a robust conceptual foundation against which a rich array of intriguing visuals can be displayed, in order to convey the depth and uniqueness of Japan.

A JAPANESE DESIGN
(2005)

I was asked to develop the package design and create a
name for rice grown in Hokkaido, Japan's northernmost
large island. In the rest of Japan, rice grown in Hokkaido
used to have a negative image as cheap and unappetizing,
but after learning that recent developments in selective
breeding now produce rice rivaling the very best grown on
the mainland, I tasted it. I found it quite delicious.

Our quest was to see how far we could raise the image
of Hokkaido rice. I had always wondered how package
designs for rice, so essential to our lives and the natural
environment of Japan, wound up with infantile manga-type
characters or tasteless illustrations, so "un-Japanese." My
team and I determined we would develop an entirely new
approach. We considered a range of names in various designs,
but the client chose the one pictured. We had proposed
naming the rice 八十八 Hachijū-hachi, Eighty-Eight, but that
was already trademarked, so we named it 八十九 Hachijū-ku,
Eighty-Nine. 米 *Kome*, the kanji for rice, is composed of the
characters for "eighty-eight," 八十八, from the legend that

eighty-eight steps are involved in producing rice. I think the name Eighty-Nine, conveying that this rice is produced with one extra step, makes for a better story than Eighty-Eight, and is ultimately the better name. The final design is nothing more than that name rendered in a large, distinctive font that's instantly recognizable. In the midst of so many multicolored, flamboyant designs, I think this unaffected packaging in muted colors feels quintessentially Japanese, with its own contrasting presence.

SURFING

I took up surfing when I was twenty-seven. There were times I got hurt, times when I hurt other surfers because I was clumsy, and times when my board got swept up in a big wave and crashed on my head, nearly knocking me unconscious. But come Saturday, I always set off for the beach. When a typhoon is approaching, I'll often get caught in a big wave and can't reach the surface as I flounder and struggle, my face clearing the water just before I run out of breath, only to be swallowed up in the next gigantic wave. Whenever that happens, I start seeing stars and fear I may not make it this time. Perhaps only surfers can understand the impulse that takes me right back to the surf after surviving another close call. I grew to treasure surfing to an outrageous degree.

Eventually, I learned to ride a stable board upright, and on windless days when the water is quiet and a wave my height approaches, the thrill of anticipation overwhelms me. You see, I can intuit which wave is perfect for me. When the wave conditions are good, larger waves come in sets. I train

my focus on one of the rhythmically arriving waves and get ready to ride it. At takeoff, I start paddling, and when the water lifts the rear of the board and just as I'm about to slide straight down to the bottom of the wave, my body reacts, and with hardly time to think about putting my right or left foot forward, I rise up on the board, barely engaging my conscious brain, and I'm riding the slope of the wave. The moment I'm standing on water on the verge of that glide, I experience an incomparable sense of 無 *mu*, nothingness. Unless I free my mind of thoughts and focus purely on that moment, I'll fall to the bottom of the hollow wave, be assaulted by a tower of water, and wipe out with my board. But whenever I catch a wave, my entire body thrills to the power of fusing with a force of nature.

As we age, accumulating experience, human beings tend toward arrogance. We want to resolve things in our heads. But that doesn't work when you're up against nature. In the face of its relentless power, there's no time for logical thinking. Surfing makes it crystal clear, to a laughable degree, just how powerless I really am. The weak yield the waves to the strong. If surfers half my age are better at negotiating nature, the waves belong to them. This unassailable logic gives me great pleasure. No human power can push back a wave, and when good waves are scarce, you have no choice but to wait. Enjoy surrendering to the rhythms of nature. Instead of putting yourself first, examine your environment and train your body to react to whatever comes your way. This is exactly how I approach design.

MESSAGE FOR THE TWENTY-FIRST CENTURY / SURFER & DESIGNER : TAKU SATOH

ALWAYS A GRAPHIC DESIGNER

When someone asks me my job title, I tell them I'm a graphic designer. I really don't care about titles, but society insists on categorizing people. In Japanese, the word 解る *wakaru*, to understand, derives from the word 分ける *wakeru*, to separate. You separate in order to convince yourself that you understand. This is also why Japan's Decimal Classification exists: because countries and governments feel less threatened when they divide things up into categories. Separating things doesn't actually help you understand them any better, but people want to do it anyway. That being said, it's exhausting to fight this impulse all the time, so when someone asks me my title, I have no hesitation responding, "Graphic designer." Some people change their title as they take on different kinds of work, and some people claim two or three titles, but that doesn't appeal to me. I just don't trust it.

Having thought it over, I decided to accept that using a title is a way to convey your skills to someone. Namely, I use "graphic designer" as my title because I have the skills of a graphic designer. There is no rule that says expertise in

graphic design can only be applied to graphic design. You can use those skills for anything. The reason I gravitated to diverse projects in the first place is because my interests go well beyond two-dimensional print media, to encompass three-dimensional media, space, sounds, and taste. But more importantly, I hoped to shatter preconceptions about graphic design and expand its scope. When people see that "a graphic designer can do that!" it helps broaden the expectations of a graphic designer's potential. If you surmise everything, from letters to visual and moving images, from three-dimensional projects to all that is visible, even rendering the invisible visible, then a mountain of work awaits you. If you believe that all the information we receive from our visual sense is material for graphic design, then, however the world may change, there will always be work to do.

But no matter how I logically analyze it, I simply love using my hands to draw. These days every task winds up as data, but I still draw every single line without aid of a computer, and I sketch out all my ideas by hand. Sometimes I use that hand-drawn quality in the final result. I am not denying the digital. But we are blessed with human bodies that cannot be traded in for machines, so why not put them to work?

We must begin to have the perception that product design is part of living environment design when we are flooded by a very large number of products. There is the idea that products do not exist independently, but exist because of their relationship with products around them. The relationships involve not only products of the same kind, but also their surroundings. The time has come when the design of a package must move awareness to the consumer's side, instead of manufacturing product while thinking only of the supplier. Perhaps it is now time to re-examine the approach of "Sell or nothing", giving the highest priority to the pursuit of profit as a product of capitalist society. ■ From now on, the supplier will be required to provide each product carefully in the firm belief of what they would like to do for society. Instead of thinking that everything ends when supplies produce the products people want. There will be a clear distinction between products that are mere material sold to dull, uninterested and those that are manufactured giving the highest priority to profit. Rather than "there will be", the trend will be "these must be". Nevertheless, the present tendency is still that products sold, violating their design have

to be good. Products based on a unique concept are sold if they are communicated well even if their design is not good. There are suppliers which think, "Products are good if their substance is good". Designers frequently feel that designs are trailing in the air. Such designs cannot be given a final product form under the situation unless there is a firm strong belief in the product. ■ There is a world in which desperately wanted articles cannot be obtained. Trite to say, a world in which unnecessary articles flood us without us noticing them. I suppose to exist in the latter world and this is why I can say this. However, I say that there exist an exsense of uncertainty when one creates a new article in the lavous world. From now on, we cannot merely sell goods to people without taking responsibility for the things following. Environmental problems have come closer to us. This is why the time has come to say good bye to the age in which articles can say anything as long as they please.

TAKU SATOH DESIGN OFFICE INC. ● KOBU TSUKIJI BLDG. 5F, 3-10-9 TSUKIJI CHUO-KU TOKYO JAPAN 〒104, PHONE 03-3546-7901 FACSIMILE 03-3544-0067

Glossary

bokoboko: bumpy

Bunraku: classical puppet theater

byōbu: folding screens

furoshiki: wrapping cloth

fuwafuwa: fluffy

geisha: professional entertainer

guruguru: going around in circles

hachijū-hachi: eighty-eight

hachijū-ku: eighty-nine

hashi: chopsticks

hiragana: the basic Japanese phonetic alphabet, used with kanji, Japanese characters, to write Japanese

hisohiso: whispering

hodo-hodo: just enough

isshōbin: sake bottle slightly larger than a magnum of wine

izakaya: tavern serving drinks and small plates of food

Kabuki: highly stylized classical drama-dance performance

kanji: Japanese characters, originally adapted into Japanese from logographic Chinese characters

katakana: Japanese phonetic alphabet used for words adapted into Japanese from another language

kawaii: cute

kome: uncooked rice

Kyōgen: classical comic relief performance

mingei: folkcraft

mu: nothingness

Nihongo de Asobo, Let's Play in Japanese: television program

noren: doorway curtain

ochoko: small sake cup

oishii: tasty, delicious

ramen: noodle soup

shizen: nature

sho: charcoal ink calligraphy

shokunin: artisan

tema hima: to spend time and effort

tokkuri: sake carafe

ukiyo-e: "floating world" woodblock prints

wakaru: to understand

wakeru: to separate

washi: handcrafted paper

Image Credits

Page 11

Pleats Please Issey Miyake Animals (2015)

GRAPHIC

Art Director: Taku Satoh
Designer: Taku Satoh, Shingo Noma
Client: Issey Miyake, Inc.

Page 19

Photograph provided by MUSUBI,
Yamada Sen-I Co.

Page 20

Freer Gallery of Art, Smithsonian
Institution, Washington, D.C.;
Gift of Charles Lang Freer, F1896.82 /
Photograph by Norimichi Kasamatsu

Pages 22, 24, 25

Nikka Pure Malt (1984)

PLANNING AND DESIGN

Art Director: Taku Satoh
Designer: Taku Satoh
Client: The Nikka Whisky
 Distilling Co., Ltd.

Page 29, bottom

Photograph by
Paylessimages-stock.abode.com

Page 34, top

Ginza Hachi-Go (2018)

CREATIVE DIRECTION, DESIGN

Creative Director: Taku Satoh
Art Director: Taku Satoh
Designer: Ayame Suzuki
Client: Ginza Hachi-Go

Page 36

The First Electronic Rice-Cooker
in Japan (Toshiba in 1955),
photograph provided by Toshiba
Science Museum

Pages 40, 41

Max Factor "fec." (1986)

PRODUCT

Designer: Taku Satoh
Client: Max Factor Co., Ltd.

Page 42

Lotte Xylitol Chewing Gum (1997~)

PACKAGING

Art Director: Taku Satoh
Designer: Taku Satoh, Kyoko Kagata
Client: Lotte Co., Ltd.

Page 45

21_21 Design Sight (2007)

LOGO

Art Director: Taku Satoh
Designer: Taku Satoh, Ichiji Ohishi
Client: 21_21 Design Sight

Pages 46, 47

Exhibition "Design Ah!" (2013)

EXHIBITION

Exhibition Director: Taku Satoh,
 Yugo Nakamura
Creative Director, Art Director: Taku Satoh
Designer: Rikako Hayashi
Organization: 21_21 Design Sight
 NHK Educational Corporation,
 NHK (Japan Broadcasting Corporation)

Pages 82, 84, 85, 86

A Rooftop of Onomatopoeia
@Toyama Prefectural Museum of Art
and Design (2017)

PLANNING, DESIGN

Art Director: Taku Satoh
Designer: Taku Satoh, Ayame Suzuki
Client: Toyama Prefectural Museum of
 Art and Design

Pages 88, 90, 91, 93

Hoshiimo-Gakko (2007~)

REGIONAL PROJECT LEADER

Art Director: Taku Satoh
Designer: Taku Satoh, Natsuko Fukuhara
Client: General Incorporated Association
 Hoshiimo-Gakko

Page 94

Pleats Please Issey Miyake Bento Box
(2005)

GRAPHIC

Art Director: Taku Satoh
Designer: Taku Satoh, Ichiji Ohishi
Client: Issey Miyake, Inc.

Page 96, top

Pleats Please Issey Miyake Animals (2015)

GRAPHIC

Art Director: Taku Satoh
Designer: Taku Satoh, Shingo Noma
Client: Issey Miyake, Inc.

Page 96, bottom

Pleats Please Issey Miyake Flowers (2014)

GRAPHIC

Art Director: Taku Satoh
Designer: Taku Satoh, Shingo Noma
Client: Issey Miyake, Inc.

Page 97, top

Pleats Please Issey Miyake
Happy Anniversary (2012)

GRAPHIC

Art Director: Taku Satoh
Designer: Taku Satoh, Shingo Noma
Client: Issey Miyake, Inc.

Page 97, bottom

Pleats Please Issey Miyake Vitamin (2017)

GRAPHIC

Art Director: Taku Satoh
Designer: Taku Satoh, Yuri Yamazaki
Client: Issey Miyake, Inc.

Page 99

Pleats Please Issey Miyake Sea (2018)

GRAPHIC

Art Director: Taku Satoh
Designer: Taku Satoh, Yuri Yamazaki
Client: Issey Miyake, Inc.

Page 101

Issey Miyake Paris Collection
1977→1999: invitation by
Tadanori Yokoo (2005)

BOOK

Art Director: Taku Satoh
Designer: Taku Satoh, Ichiji Ohishi,
 Yusei Sone
Client: Bijutsu Shuppan-Sha, Ltd.

Page 102

Aizu Kiyokawa (1989)

PACKAGING

Art Director: Taku Satoh
Designer: Taku Satoh
Client: Kiyokawa Shohten

Pages 107, 108, 111

Exhibition "TEMA HIMA:
the Art of Living in Tohoku" (2012)

EXHIBITION

Exhibition Director: Taku Satoh, Naoto
 Fukasawa
Designer: Taku Satoh, Ken Okamoto
Organization: 21_21 Design Sight

Page 112

Photograph by
ChocolateShot-stock.adobe.com

Page 115

Nikka Whisky from the Barrel (1985)

PACKAGING

Art Director: Taku Satoh
Designer: Taku Satoh
Client: The Nikka Whisky
 Distilling Co., Ltd.

Pages 118, 121

P.G.C.D. (2000~)

PACKAGING, PRODUCT

Art Director: Taku Satoh
Designer: Taku Satoh, Shino Misawa
Client: P.G.C.D. Japan, Inc.

Page 122

"Meiji Oishii Gyunyu" (2001~)

PACKAGING:

Art Director: Taku Satoh
Designer: Taku Satoh, Shino Misawa
Client: Meiji Co., Ltd.

Page 129

Hokuren rice (2005~)

PACKAGING

Art Director: Taku Satoh
Designer: Taku Satoh, Yusei Sone
Client: Hokuren Federation of Agricultural
 Cooperatives

Page 130

Taku Satoh surfing,
Photograph by Clark Little

Page 133

Exhibition "Message for the
Twenty-First Century" (1999)

POSTER

Art Director: Taku Satoh
Designer: Taku Satoh
Organization: Japan Design Committee

Page 134

Taku Satoh Drawing Tokyo 2020 Official
Art Poster Olympic Cloud (2020)

POSTER

Art Director: Taku Satoh
Designer: Taku Satoh
Organization: The Tokyo Organising
 Committee of the Olympic and
 Paralympic Games

Page 137

Poster "Taku Satoh Design Office Inc."
(1991)

POSTER

Art Director: Taku Satoh
Designer: Taku Satoh

About the Author and Translator

Taku Satoh was born in Tokyo and graduated in 1979 from Tokyo University of the Arts with a major in design. He completed his graduate studies at the same university in 1981. After initially working for Japan's largest advertising agency, Dentsu, he established Taku Satoh Design Office in 1984. Starting with the product development of Nikka's Pure Malt, he has created well-known package designs for prominent Japanese brands, including Lotte's XYLITOL chewing gum and Meiji's Oishii Gyunyu milk, and the graphic design for PLEATS PLEASE ISSEY MIYAKE. He conceived the logos for the 21st Century Museum of Contemporary Art in Kanazawa, the National Museum of Nature and Science in Tokyo, and the National High School Baseball Championship.

Taku is codirector of the 21_21 DESIGN SIGHT gallery. He has served as art director for the *Nihongo de Asobo* children's program on the Japan Broadcasting Corporation (NHK) and as overall supervisor of NHK's *Design Ah!* children's program, which won the World Media Festival Award, the Prix Jeunesse International Award, the US International Film & Video Festival Award, and the George Foster Peabody Award.

Taku himself has received numerous awards, including the Cannes Lions International Festival Award, a Gold Cube from the New York Art Directors Club, the Good Design Award Grand Prize, and the Minister of Education Award for Art Encouragement, as well as awards from the Japan Graphic Designers Association and the Tokyo Type Directors Club. In spring 2021, he was given the Medal with Purple Ribbon by the emperor of Japan. He resides in Tokyo.

Linda Hoaglund is a bilingual filmmaker born and raised in Japan. The daughter of American missionary parents, she attended Japanese public schools and graduated from Yale University. She has directed and produced five feature-length films about art and the relationship between Japan and the United States.

Hoaglund has also subtitled 250 Japanese films, including *Seven Samurai* by Akira Kurosawa, *Spirited Away* by Hayao Miyazaki, and *Battle Royale* by Kinji Fukasaku. She has translated Kabuki performances at Lincoln Center in New York City and essays by Issey Miyake, Miyako Ishiuchi, Tadanori Yokoo, Natsuo Kirino, Daido Moriyama, Shomei Tomatsu, Takashi Murakami, Tadao Ando, and other renowned artists and writers. She resides in Hawaii.